HOT GUYS
and KITTENS

Audrey Khuner *and* Carolyn Newman
Photography by Eliot Khuner

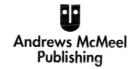

Andrews McMeel
Publishing

Kansas City • Sydney • London

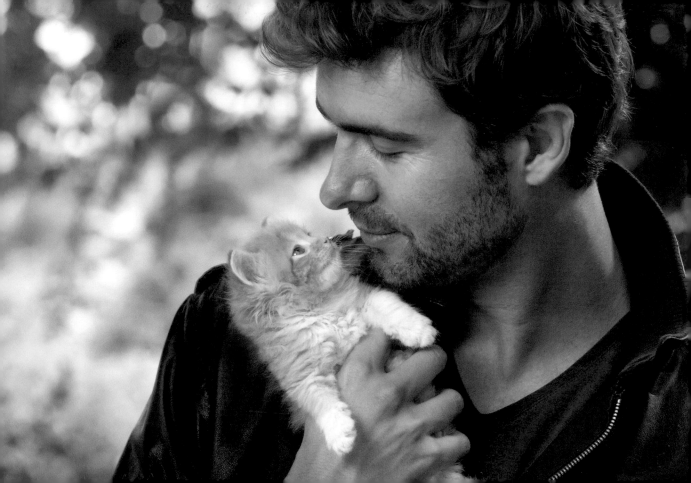

ALBERTO *and* RUM TUM TIGER

Alberto's first language is Spanish.

Rum Tum Tiger's first language is Love.

BRENDAN
and PUMPKIN

Brendan enjoys spending time in nature.

Pumpkin thinks leaves are out to get us.

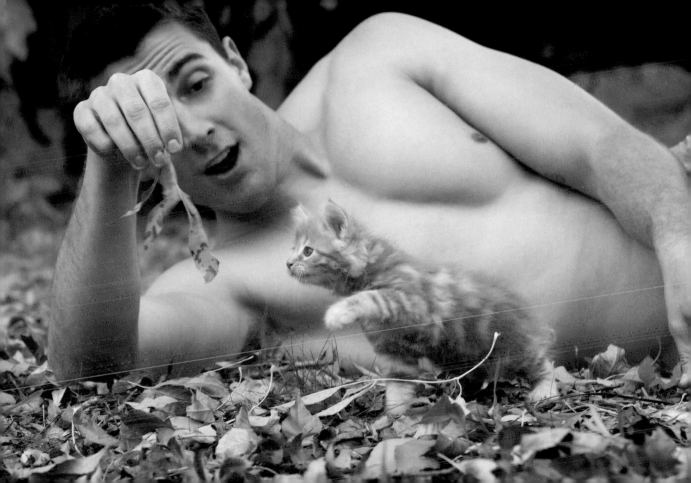

MATTHEW and KELIS

Matthew loves to drink milkshakes.

Kelis's milkshake brings all the boys to the yard.

LEO and LUCY

Leo likes to use Lucy as a dumbbell.

Lucy likes to use Leo as a chair.

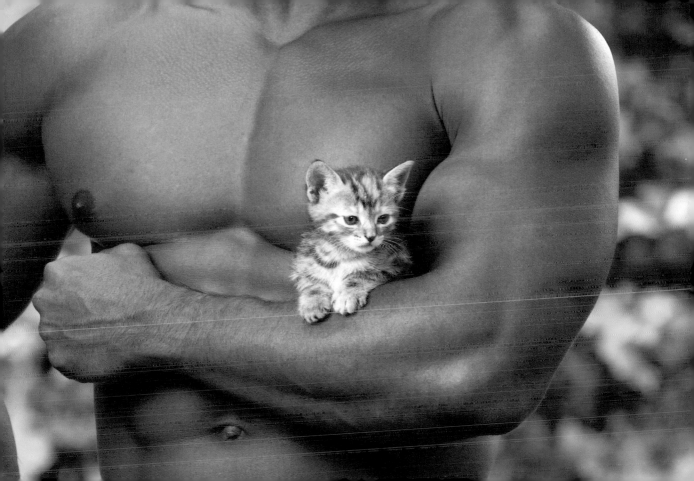

ADAM and MINKY

Adam can get ready to go in five minutes.

Minky takes at least an hour.

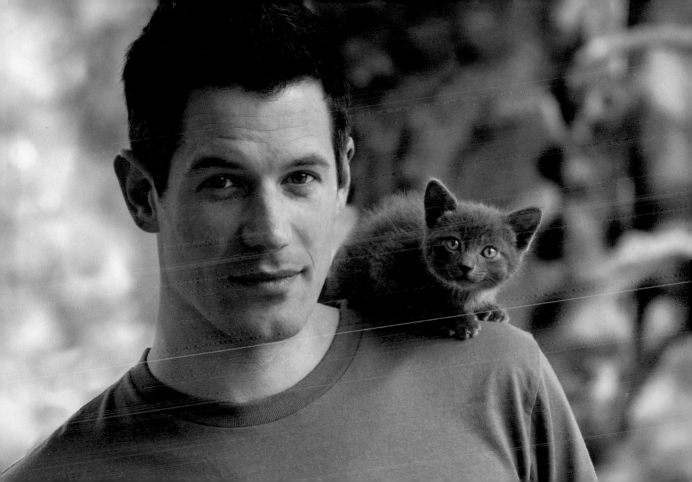

GIAN *and* GROVER

Gian practices meditation.

Grover finds his nirvana in Gian's arms.

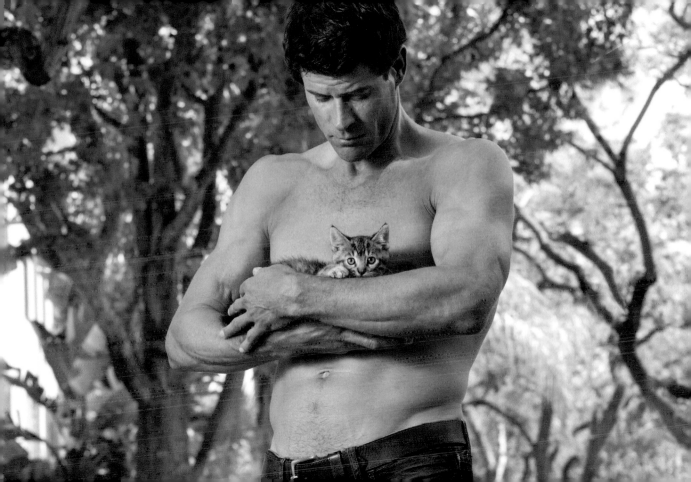

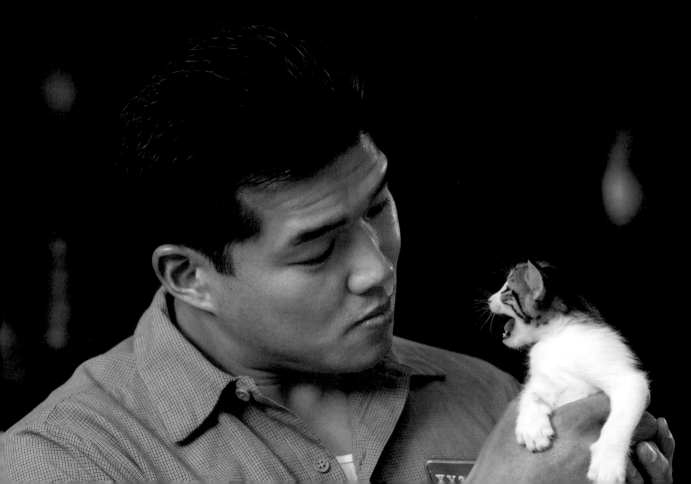

RYAN and SPIKE

Ryan is calm and collected.

Spike is loud and irrational.

TYLER and HENRY

Tyler is a fan of the Pittsburgh Steelers.

Henry is a fan of stealing socks.

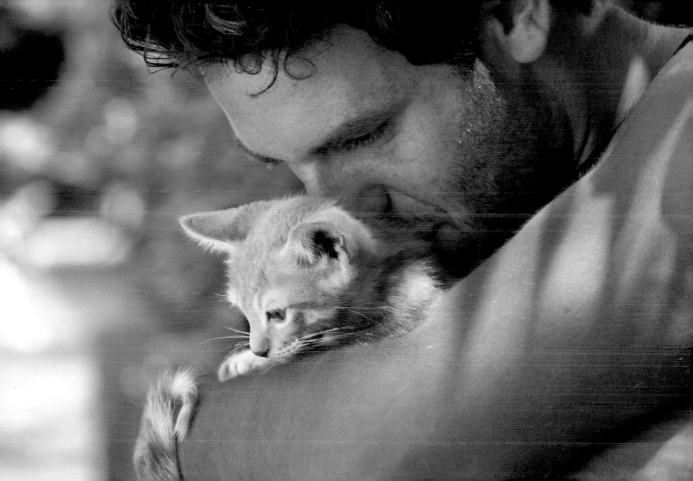

DAVID and ISIS

David was a Super Mario Bros. champ as a kid.

Isis kicks ass at Grand Theft Auto.

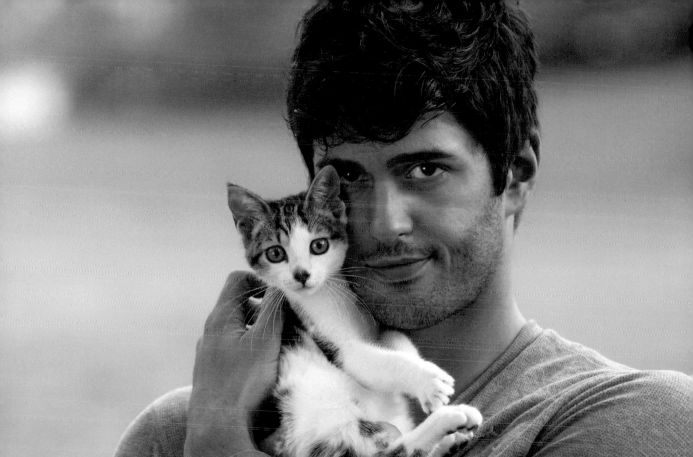

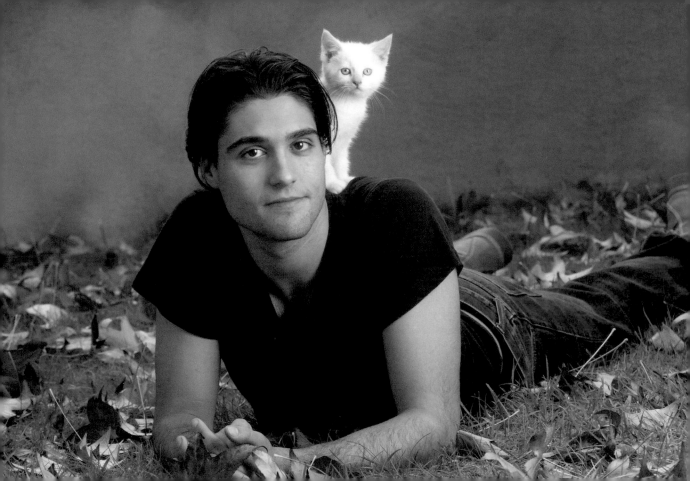

JAYSON and LILY

Jayson likes to surf the waves.

Lily likes to surf Jayson.

MATT and NUAGE

Matt, a human, has five toes on each foot.

Nuage, a highland lynx, has six toes on each paw.

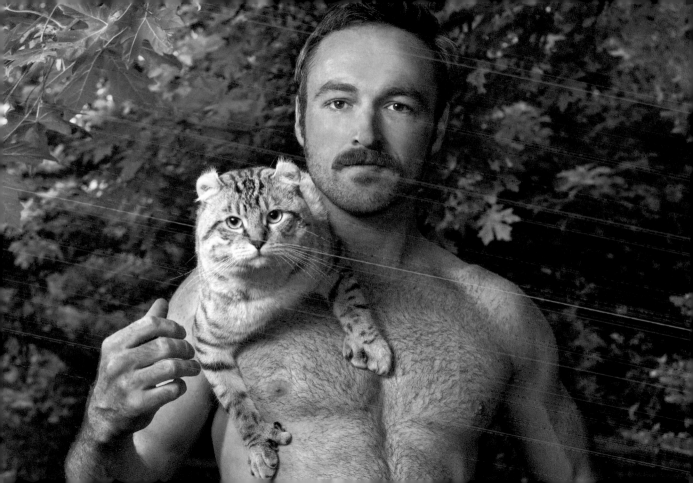

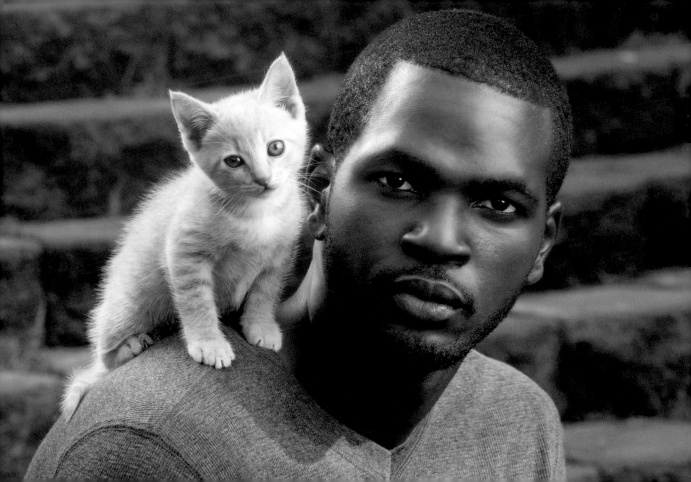

RONALD and PACO

Ronald likes bowling and basketball.

Paco prefers chess.

MICHAEL *and* LARRY, CURLY, *and* MOE

Michael has his hands full of kittens.

Larry, Curly, and Moe have heads full of quirky ideas.

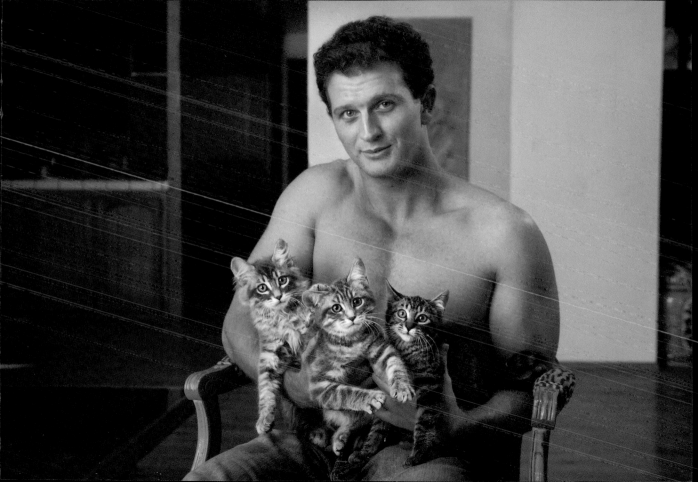

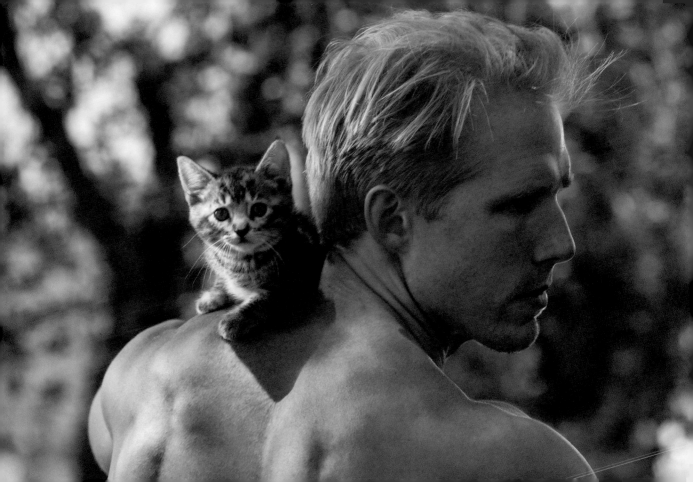

Jason is playing hard to get.

Bartholomew likes to make a good first impression.

BRENDAN and PUMPKIN

Brendan loves pumpkin pie.

Pumpkin loves tuna casserole.

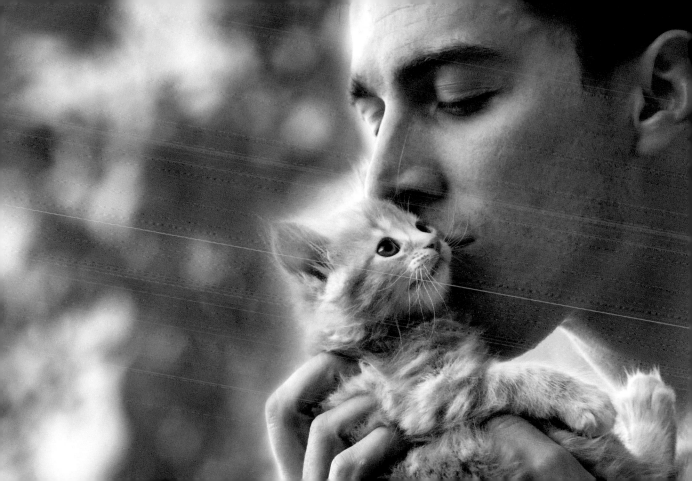

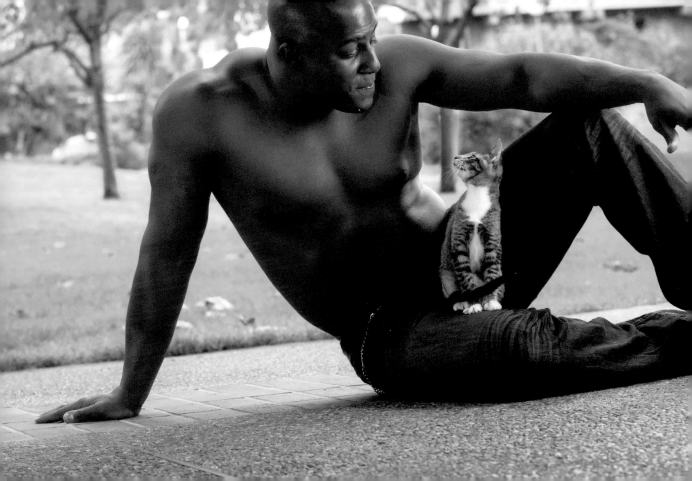

BILLY RAY and GEORGIA

Billy Ray is the father of two.

Georgia thinks of him as an uncle.

Brent and Michael sing in a band.

Socks and Mittens are groupies.

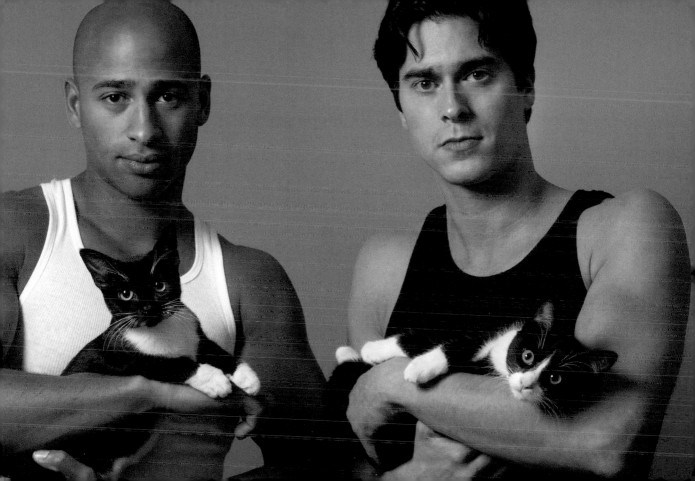

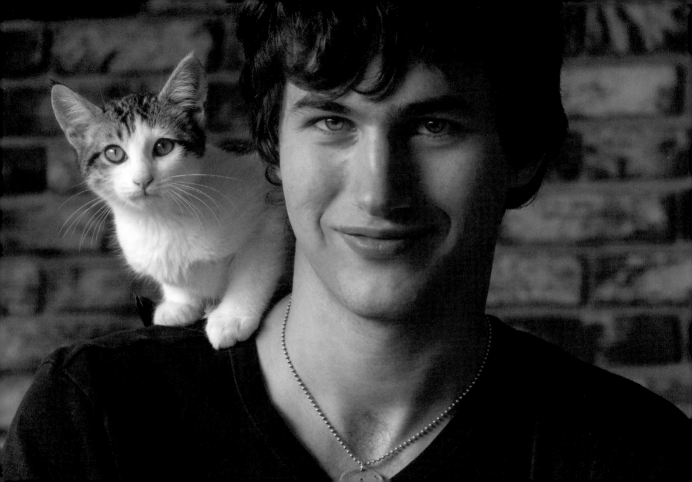

ROBY and DORIS

Roby plays guitar in a rock band.

Doris is his number one fan.

MATT *and* MR. FURRYBOTTOM

Matt likes to date older women.

Mr. Furrybottom has grown weary of love.

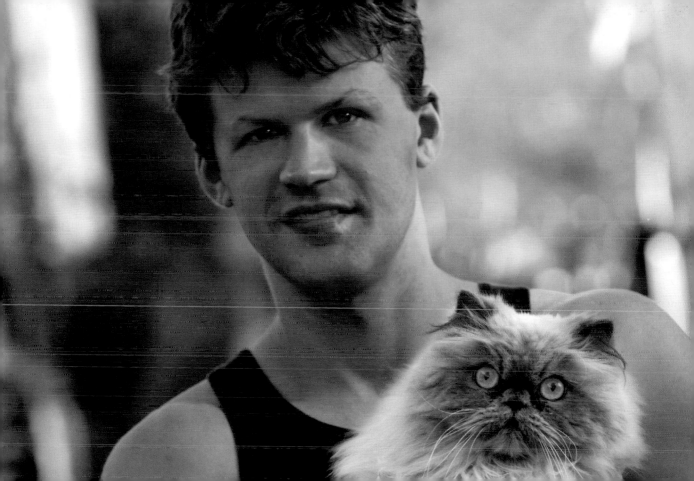

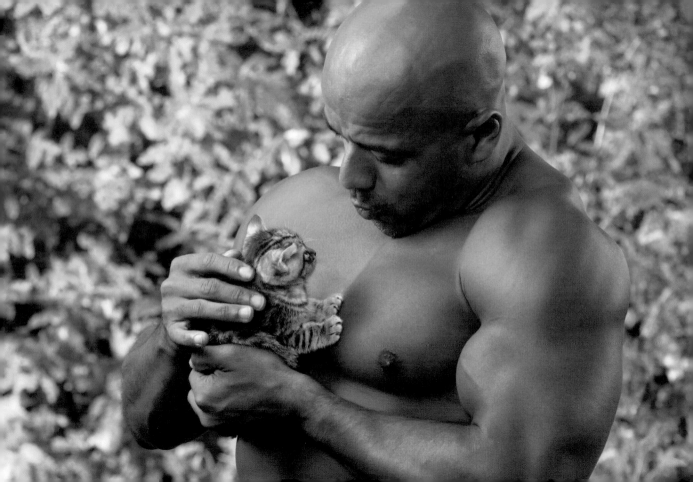

LEO and LUCY

Leo has a soft spot for kittens.

Lucy has a soft spot for Brazilian bodybuilders.

BIVAS and SHADOW

Bivas is serious about acting.

Shadow is serious about tuna.

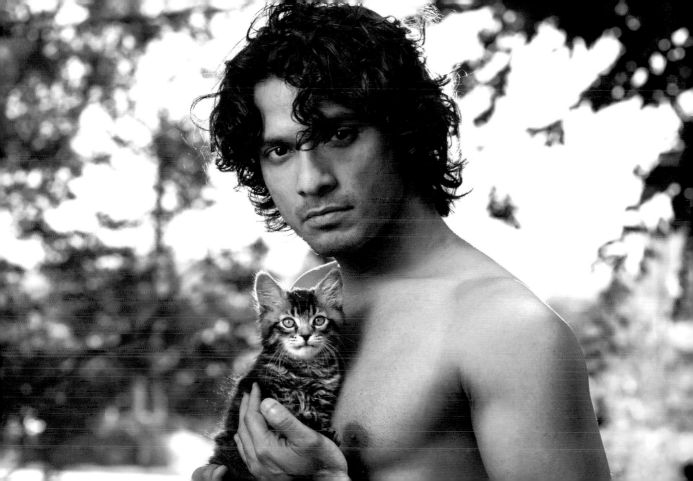

RYAN
and SPIKE

Ryan loves meeting new people.

Spike is wary of strangers.

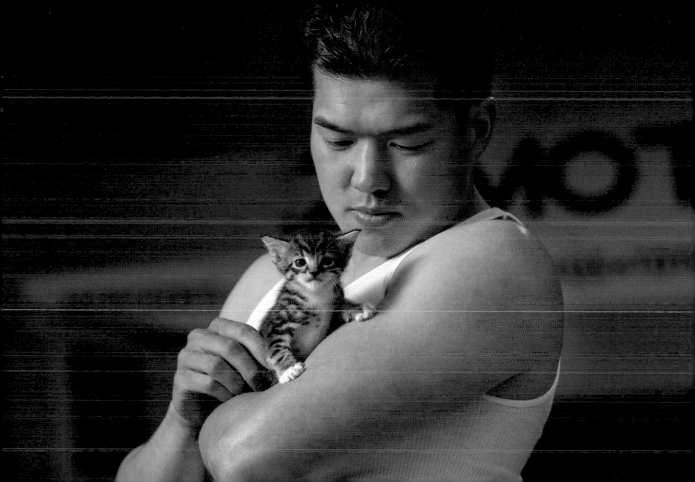

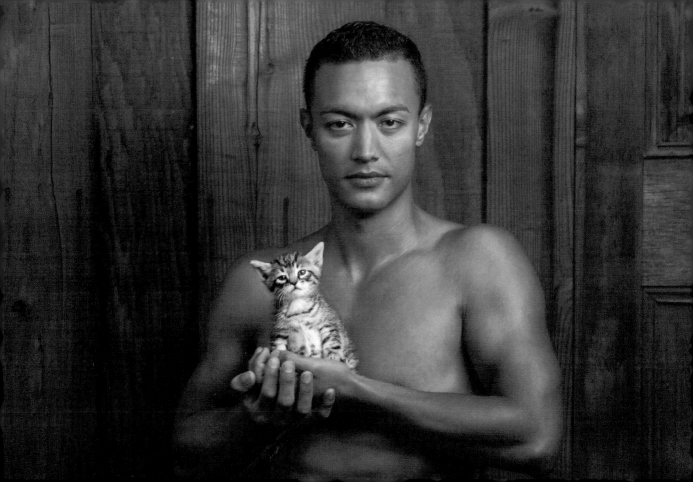

BRANDON *and* BOBBIE

Brandon has bedroom eyes.

Bobbie has a seductive purr.

ADAM and MINKY

Adam plans to run for city council someday.

Minky is plotting world domination.

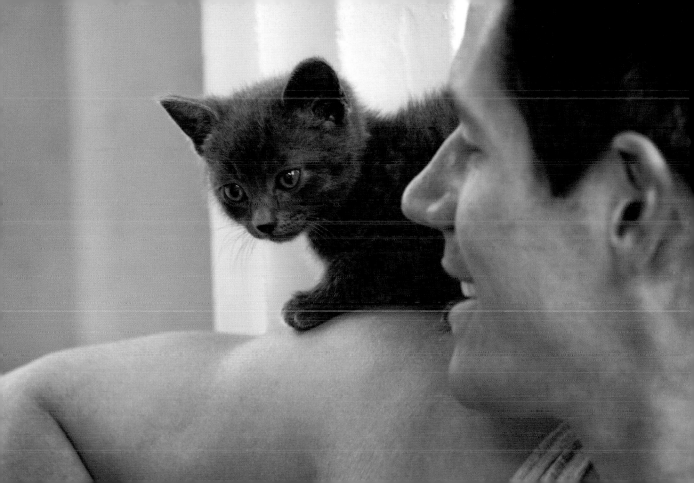

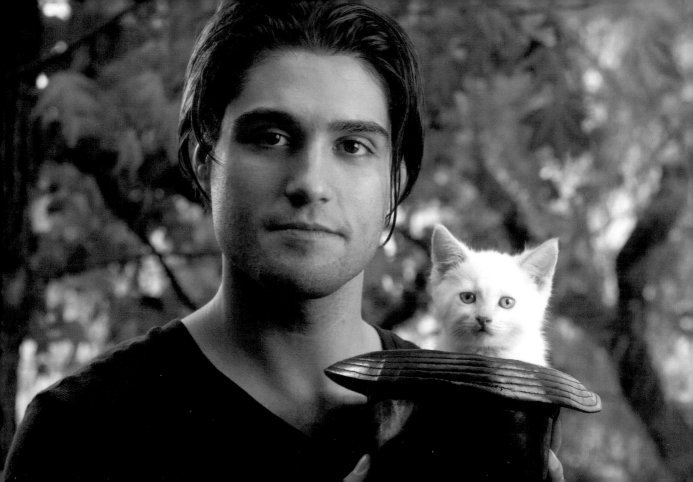

JAYSON and LILY

Jayson moonlights as a magician.

Lily moonlights as a cocktail waitress.

RONALD
and PACO

Ronald is proud of his tattoos.

Paco wants to get a nose ring.

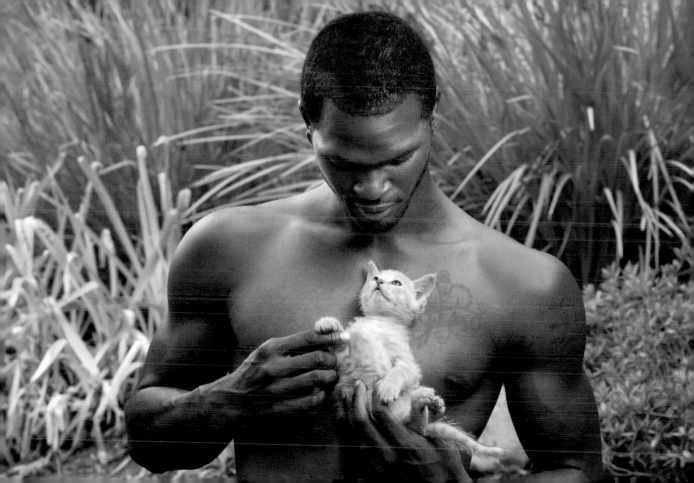

ALBERTO *and* **LILIANA**

Alberto has a keen sense of direction.

Liliana has an above average sense of balance.

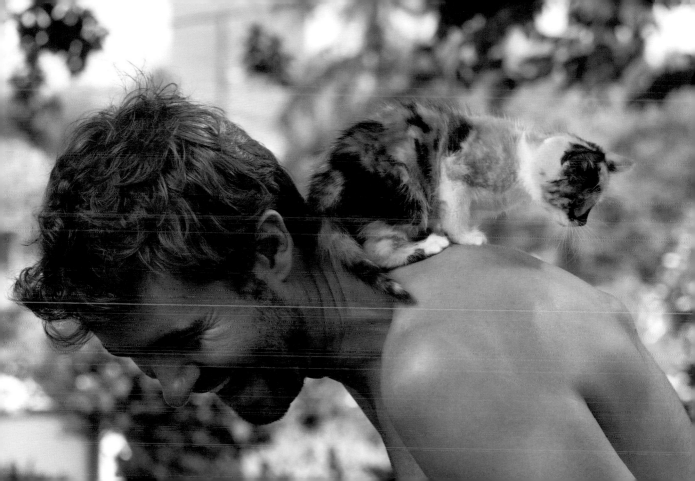

MARK
and ALFONSO

Mark likes having his picture taken.

Alfonso believes the camera steals his soul.

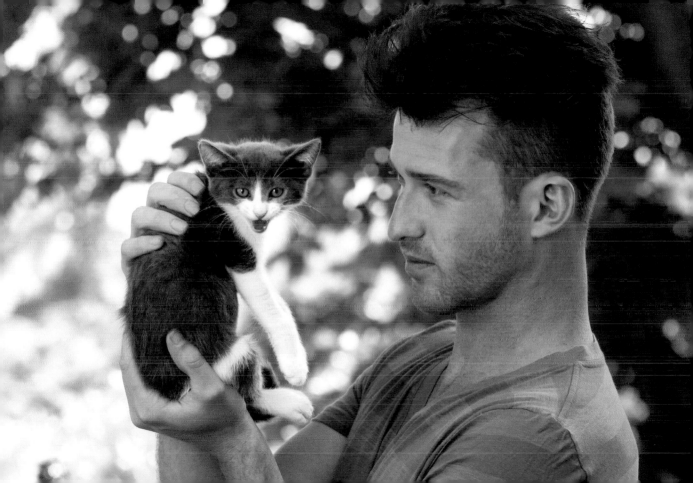

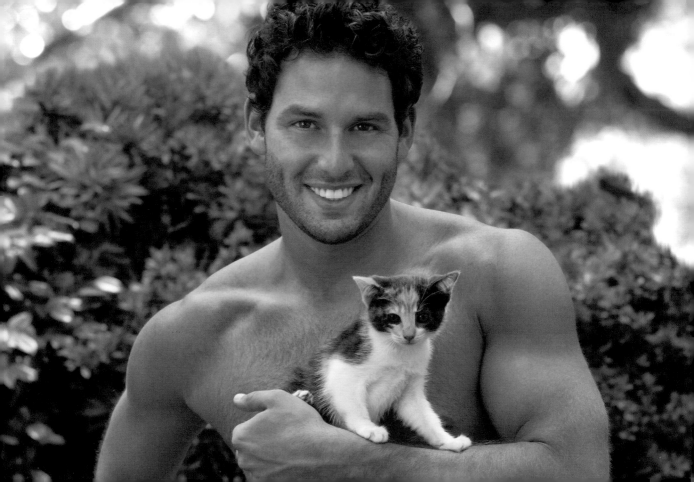

Tyler is scared of heights.

Mike is scared of bubble wrap.

TODD
and HUNTER

Todd has been to Burning Man three years in a row.

Hunter likes to play with fire.

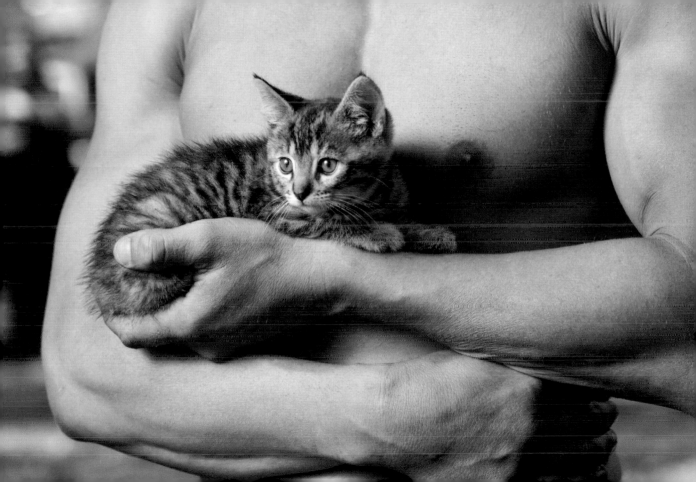

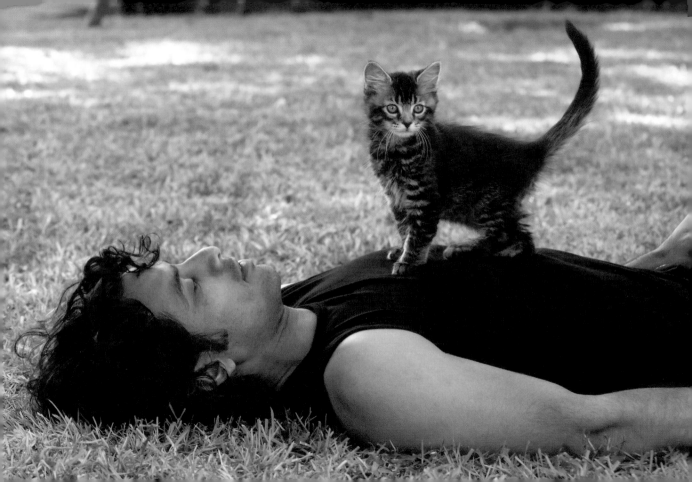

BIVAS *and* SHADOW

Bivas likes to relax in the grass.

Shadow keeps an eye out for cute girls.

GIAN and ROSIE

Gian was an air traffic controller.

Rosie always lands on four feet.

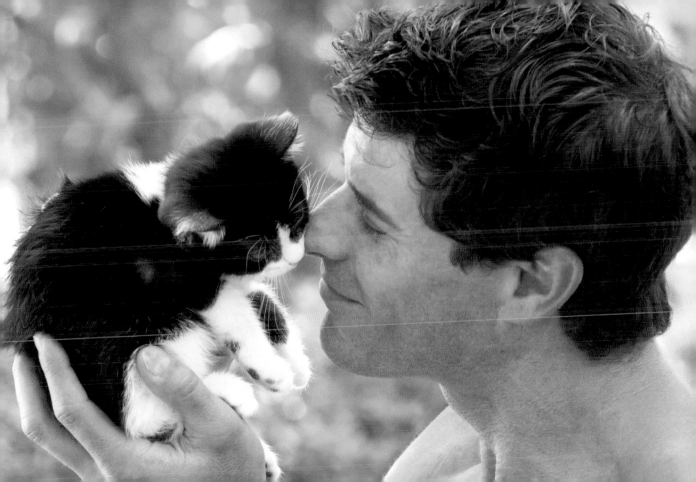

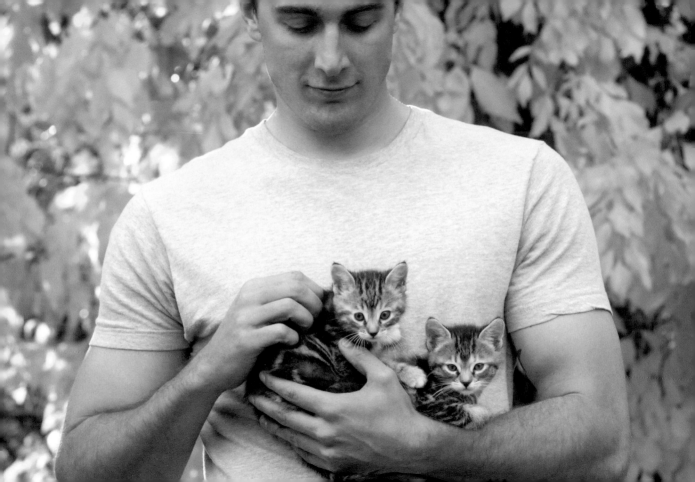

BRENDAN
and BONNIE
and CLYDE

Brendan is a law-abiding citizen.

Bonnie and Clyde rob banks.

ALBERTO
and **LILIANA**

Alberto is from Spain.

Liliana is taking flamenco lessons.

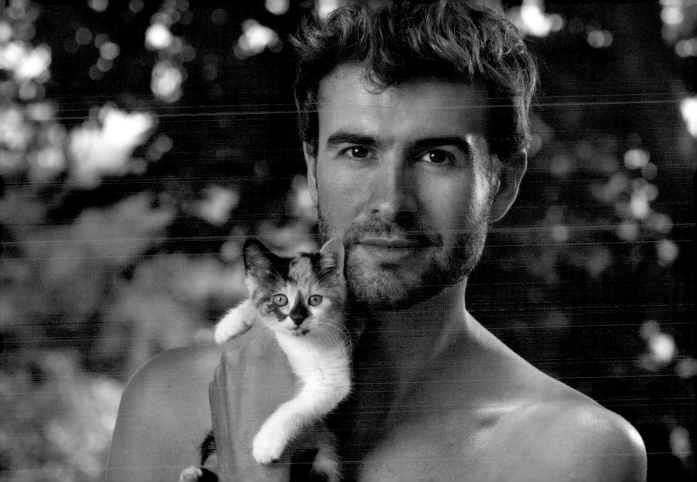

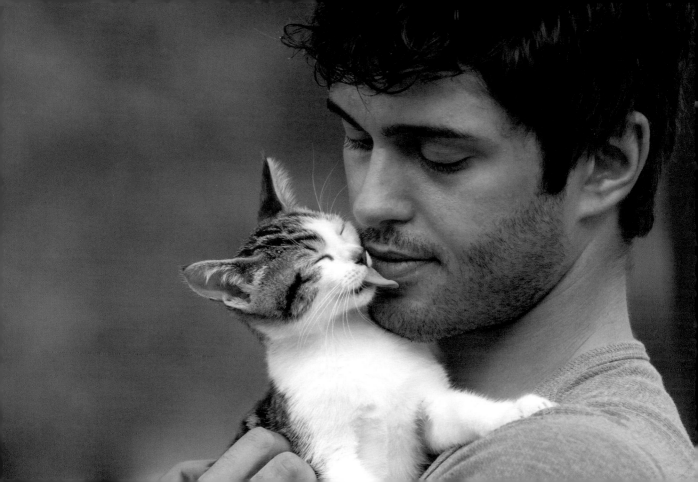

DAVID *and* ISIS

David likes the taste of chicken piccata.

Isis likes the taste of David.

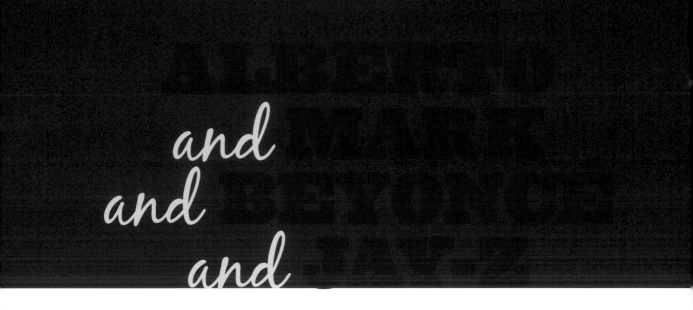

Alberto and Mark are talented swingers.

Beyoncé and Jay-Z are talented singers.

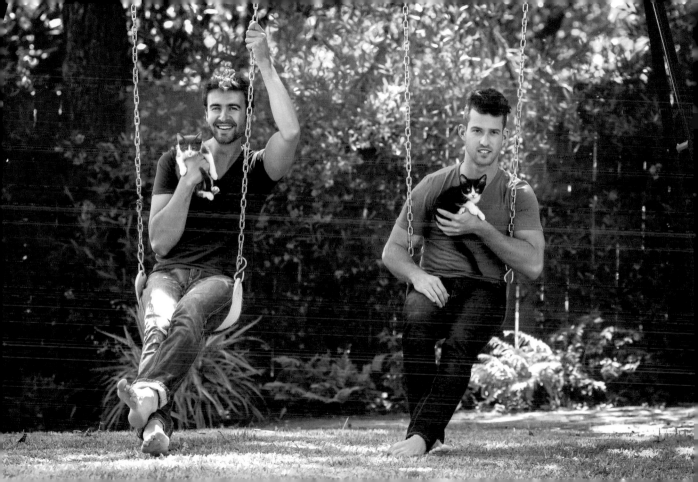

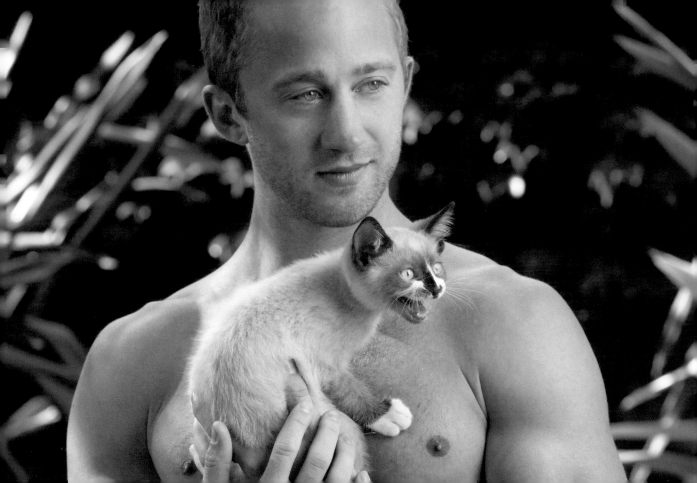

MATTHEW
and SPHINX

Matthew welcomes new people.

Sphinx guards against intruders.

LEO
and JULIUS

Leo is considering his afternoon workout.

Julius is considering his afternoon nap.

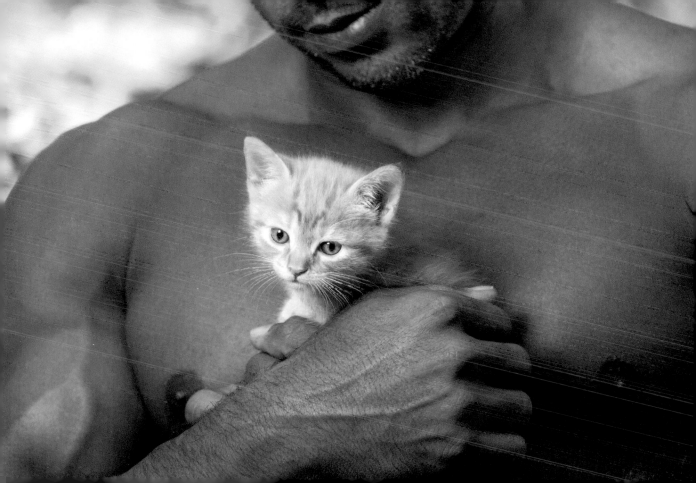

Andrews McMeel Publishing, LLC
an Andrews McMeel Universal company
1130 Walnut Street, Kansas City, Missouri 64106

www.andrewsmcmeel.com

14 15 16 17 18 SHO 10 9 8 7 6 5 4 3 2 1

ISBN: 978-1-4494-5496-8

Library of Congress Control Number: 2014932877

Also available: *Hot Guys and Baby Animals, Hot Guys and Cute Chicks*
www.hotguysandbabyanimals.com

Attention: Schools and Businesses
Andrews McMeel books are available at quantity discounts with bulk purchase
for educational, business, or sales promotional use. For information, please
e-mail the Andrews McMeel Publishing Special Sales Department:
specialsales@amuniversal.com.